THE PHOTOGRAP
A Guide for Teachers

Michael F. O'Brien and Norman Sibley

Davis Publications, Inc., Worcester, Massachusetts

Copyright 1995
Davis Publications, Inc.
Worcester, Massachusetts, U.S.A.

Coordinating Editor:
 Claire Mowbray Golding

Production Editor: Nancy Wood Bedau

Design: Janis Owens

Production Artist: Tricia Deforge

Manufacturing Coordinator:
 Steven Vogelsang

Printed in the United States of America

ISBN: 87192-284-3

10 9 8 7 6 5 4 3

Contents

Introduction

TECHNIQUE VS. CREATIVE EXPRESSION

Like any form of art or craft, photography employs technical skills to facilitate creative expression. Because it requires the use of a sophisticated machine (rather than brushes and paint or other simple tools), the technical aspect of photography is especially important. However, once the basic mechanics have been mastered, photographers are exceptionally free to explore the creative potential of their craft, because the camera does much of the work that painters, for example, must continually strive to refine.

Ultimately, these two concerns — technique and creative expression — are complementary. Each enhances the other. In practice, however, anyone who teaches photography must make some choices about which approach will be given primary attention, take precedence as a criterion for grading purposes and promote the most productive learning experience.

Successful development of technical skills will enable students to produce photographs that are well composed, exposed and printed. For students who already possess a clear sense of visual acuity, this approach may also result in creative discovery and the depth of expression which genuine art requires. In addition, acquiring precise and systematic work habits are potentially beneficial in other kinds of endeavors. On the other hand, technique can readily become too dominant, producing results that are precise but sterile, "correct" but uninspired and flawlessly dull.

An emphasis on creative expression may result in photographs that are technically less than perfect, but it has one distinct advantage: a capacity to foster deep and lasting enthusiasm for the joy of looking, seeing and creating.

The Photographic Eye is devoted, first and foremost, to the goal of teaching photography as a medium for creative expression. The technical aspects are of course covered in considerable detail, but they are not the primary theme. Instead, *seeing* — specifically "learning to see with a camera" — is the core concern. In our experience, students who first learn to do this will quickly move on to the next step — effectively expressing what they see — and this, in turn, will give them the incentive to improve on technique. We believe that proceeding in the opposite direction, from technique to creativity, is both more difficult and less likely to be of lasting benefit.

The lessons learned through the "creative" approach extend to every facet of life, regardless of whether or not a student continues to apply them in the field of photography. Those who pursue other visual arts will do so with enhanced perception and acuity. Even if the visual arts are abandoned, students who have learned to look and see (and express what they have seen) will be enriched throughout life, trained to experience the world as a constant source of stimulating and instructive images and insights.

In addition, many of the skills and experiences gained through a course of this kind are of direct practical benefit in virtually any pursuit. Specific examples include the ability to notice and utilize detail, pattern and relation; the conceptual skills required to compose a photograph; experience in problem-solving; and exposure to the creative application of complex technology.

Photography — like any art — is both technically and creatively boundless. No one, not even a teacher, can be expected to master it all. We believe the text contains all the basic information required to get students off to a good start in photography, even if the teacher is just starting in it as well. If you already have some experience in photography, so much the better, but little or none is strictly necessary. We've attempted to make the learning process as painless — for everyone — as possible. And we urge teachers to learn with their students. The key to doing so is to provide clear, consistent structure, leaving ample room for individual tangents and discoveries.

EDITORIAL PHILOSOPHY AND STRUCTURE

The Photographic Eye is essentially intended to serve as a catalyst. Solemn pronouncements about "right" and "wrong" ways of doing things have been studiously avoided, in the hope of stimulating discussion, exploration and discovery. Both the content and style of the text are designed to support the teacher's and students' insights and experience, so each class can define its own orientation, priorities, preferences and goals.

In keeping with this approach, the bulk of the technical data (including a chapter on color photography) has been placed in the appendices — not because it is unimportant, but so each teacher may decide when to introduce specific skills. A historical survey and the basic workings of the camera are at the front, to provide a foundation. Both are deliberately brief, so students may begin producing photographs as quickly as possible.

This is very much a hands-on course, for the simple reason that information is far more likely to "stick" when learned through practical application, rather than through abstract theorizing. Depending on class structure and available resources, teachers may wish to augment the assignments provided in the text with research projects and other activities which do not require the use of a camera or darkroom. However, we believe the knowledge gained in these ways will be more meaningful (and therefore be more effectively retained) if integrated with a regular routine in which students are challenged to fulfill specific photographic tasks.

Special Features

As a glance through the table of contents will indicate, one key component of *The Photographic Eye* is the sequence of exercises, each of which is designed to achieve three essential goals:

1. reinforce concepts discussed in the text;
2. provide a gradual progression into more advanced use of the camera;
3. introduce students to the perspectives of other photographers (generally other students undertaking the same exercise).

Another essential ingredient is the series of focal points — special sections providing in-depth coverage of a concept or photographer mentioned in (or relevant to) the main text. Focal points offer an opportunity for enrichment or advanced study of some very specific topics, such as depth of field or light meters. They may also contain biographies of outstanding photographers: Alfred Steiglitz, Margaret Bourke-White and many others. Often these featured photographers are especially illustrative of the concept(s) discussed in the chapter with which they appear. For example, Margaret Bourke-White is profiled next to the text discussing photojournalism. Diane Arbus appears in the chapter entitled "Breaking the Rules."

It is important to note — and point out to students — that the vast majority of photographs in this book were taken by high school students. While many are of exceptional quality, they are largely the work of peers — not daunting masterpieces by famous artists. Some masterpieces have been included, to establish standards and provide a challenge, but the overall message of the photographic illustrations is "you too can do this."

Application

Though it is highly recommended to proceed through chapters sequentially in "Part 2 — The Elements of Photography," teachers are encouraged to vary the sequence of exercises in "Part 3 — People, Places and Things" to capitalize on local and seasonal opportunities and on the students' developing interests and needs. For example, a town fair in October should not be missed simply because it is "ahead of schedule" (see the exercise on "Fairs," pages 200 and 201). Conversely, if a number of students are having difficulty grasping a particular concept, you may wish to devote more time to it than indicated by the text (or return to it later).

Any number of variations on the exercises may, of course, be added as well. The basic framework — succinct assignment description, explanation, examples and tips — is infinitely expandable. (Some ideas along this line are included in Part II of this manual.)

Similarly, a teacher who has darkroom or other technical experience may well wish to expand coverage of these topics, possibly adding exercises specifically tailored to this purpose. Also, a number of excellent books and periodicals are available which explore topics that are beyond the scope of this textbook (see the Sources section on page 50 of this manual).

Finally, *The Photographic Eye* (as a catalyst) will ideally be integrated with whatever community resources may be locally available, in addition to a growing "library" of student work from previous years, other sources of photographs, field trips, research projects and additional activities.

Community Resources

One distinct advantage of photography as a course of study is that it has many applications in the daily life of virtually any community. As a result, there are certain to be a number of local resources that can significantly enhance your students' educational experience.

Local Newspapers

Any local newspaper (or other periodical publication) is a potential gold mine of opportunities for photography students. To begin with, you might arrange for a tour of a newspaper's production facilities, enabling students to observe firsthand how photographs are converted to the printed page. A tour might also include an introduction to the wire-service computer, showing how photographs from around the world are received and edited for local use. In addition, a photo-editor or staff photographer might be invited to explain the process of illustrating local stories and discuss how newspapers approach lighting, contrast, composition, etc. One extension of this idea would be for students to accompany a staff photographer to the scene of an actual news event. (Even something as tame as a town council meeting could be highly educational and quite exciting.)

It may also be possible to interact with a local paper on a continuing basis, providing students with an opportunity to get their photographs published and obtain invaluable on-the-job training. For example, the feature editor might be willing to assign a story to your class, explaining what kind of photographs would be appropriate, selecting the best entries and using them to illustrate the story. If successful, this kind of collaboration could evolve into a mutually beneficial, ongoing relationship, with student work illustrating perhaps one story each month. In this case, you might wish to divide the class into teams, with several students working together on a single story. One alternative would be for the newspaper to reserve a full page (again, perhaps once a month) for student photographs of the local community or to run a single student photograph as an occasional highlight.

Studio Photographers

Virtually any town (and all cities) have professional studio photographers whose services may include portraiture, advertising, print restoration or corporate promotions. The first step to taking advantage of this resource would be to arrange a presentation or field trip, inviting one or more photographers to visit the class and discuss their work or to host the class in the studio or on location.

Additional variations might include arranging for small groups of students to spend an extended period of time observing a professional photographer at work. It may also be possible to set up workshops in which students can refine their darkroom skills, learn about studio lighting or receive specialized instruction in some other aspect of professional photography.

Local photographers may also be willing to serve as judges for photographic competitions or as a panel to critique student work on a regular basis. Depending on the size of your class and the number of professional photographers in your area, you may be able to organize "mentor sessions," in which several students meet with a local photographer for specialized instruction, critiques and advice. One advantage of this kind of activity is that it would expose students to a variety of perspectives, promoting a broad awareness of photographic opinion and stimulating discussion.

Finally, don't forget the wedding photographers, nature photographers, technical photographers, print retouchers, lab technicians, camera repair shops, antique dealers and others who may have specialized skills or information to offer your class. A close inspection of the Yellow Pages may be the best place to start a busy year of informative presentations and field trips.

Galleries and Exhibits

Though the number of art galleries and exhibits featuring photography will vary according to your region and the size of your community, there is an excellent chance that you will have access to some resources along this line. If not, you may be able to create them.

One emerging trend is for restaurants to use the work of local artists and photographers to decorate their walls. If this is common in your community, it is yet another way of locating photographers who might be willing to assist you in some of the ways outlined above. A nature photographer, for example, would be another good choice for a class presentation and may also be open to escorting your class on a field trip to a local scenic area.

If none of the restaurants in your community currently include photographs in their decor, perhaps you can persuade them to start — using the

work of your students in a rotating display. One recommendation that applies to any proposal of this kind is that you should first prepare an impressive portfolio of your students' best work, so you are clearly offering a service and not merely asking a favor. In addition, be sure that the work you present is appropriate: landscapes or appealing portraits (possibly in color) are likely to be of greater interest to a restaurant than shots of the latest football game, though again this will vary according to local taste.

Any gallery or other exhibit that includes a substantial number of photographs is a fabulous opportunity for students to be exposed to the work of other photographers. Plan a field trip and follow it up with a critique session, encouraging students to voice their responses to the work they have seen. Better still, you might be able to arrange for a private viewing (at a time when the gallery or exhibit is officially closed or expecting low attendance) and do the critique right then and there. (This is of course preferable to having to remember what the photographs looked like.) Perhaps the photographer(s) featured in the exhibit would be willing to meet with your students and explain the work on display, both in terms of artistic intent and technical considerations.

When visiting a gallery or exhibit with your class, don't forget to raise practical questions as well as exploring aesthetics. For example, how are the photographs mounted and arranged? How might certain effects have been produced? What ideas, techniques or locations might students try to emulate?

Advertising Agencies

Any local advertising agency is yet another potential resource, regardless of its size or prestige. A large, "flashy" agency (the sort that produces full-color advertising spreads or sales literature for major corporations) should be willing and able to provide an exciting and highly instructive classroom presentation or tour. A smaller and more modest operation can demonstrate how photography is employed in newspaper ads or simple brochures.

There is a better chance that smaller-scale agencies will be open to more substantial (and ultimately more rewarding) collaboration as well. For example, you might be able to arrange for your class (again, possibly in teams) to assist with the photography for some advertising projects. (It may also be possible to arrange this directly with your local newspaper.) Alternatively, perhaps your class could attend some of the planning and design sessions in which agency staff decide how to approach an ad and which photographs to include in it.

If there are no advertising agencies in your community, you have an excellent opportunity to make an offer to local merchants. Ask them if they'd like

to assign an ad to your class, either for publication in the local paper or as a hypothetical experiment. This is one area in which you may wish to work together with a writing and/or art class as well — arranging for one class to produce the copy (or text) and another to handle the design and layout to accompany photographs produced by your students.

Camera Stores

Any place where cameras are sold or film is processed is a resource you should not neglect. The educational opportunities range from demonstrations of equipment to in-depth training in specialized skills.

For example, one great way to augment the "Tools" chapter of the text (page 35) is to plan a field trip to a local camera store and ask the proprietor to explain the workings of a selection of the cameras and other equipment sold there. If the store also has a darkroom (or a computerized processor) then this would be an excellent destination for a second field trip when your course progresses to that point. The camera store staff is also likely to include some accomplished photographers and to be a great source of tips regarding other photographers in your area (they are likely to know who is really good and most likely to give you a cordial reception).

Local Clubs and Organizations

There are two categories to be considered here: clubs and organizations specifically concerned with photography and others that may employ photography as an adjunct to their main activities or interests.

The first category is fairly straightforward. Many towns and cities have camera clubs whose members would be more than willing to offer advice, tutoring, slide presentations, photographs for critiques or display, or to host field trips, serve as judges or provide other valuable services. At the very least, they should be an excellent source of back issues of photography magazines. If you're unable to locate a local camera club, contact the Photographic Society of America, 3000 United Founders Boulevard, Suite 103, Oklahoma City, OK 73112, tel: 405-843-1437.

One word of caution: some camera clubs are highly conservative in their photographic tastes and quite dogmatic in their views regarding composition. They may still be very useful resources, but — as always — we recommend that you encourage your students to question and challenge any aesthetic opinions that may be presented as absolute "rules."

The second category of clubs and organizations — those for which photography is not a primary concern — invites more creativity and imagination. If your community is blessed with a local historical society, it may have

a wealth of old photographs of interest to your students — which they might help restore by doing copy-photography and making new prints. (Once again, an exhibit is certainly possible for this, and the local newspaper might want to run some of them.) There may be a performing arts school that would be grateful for the assistance of student photographers. A bird-watchers' club might be a good source of ideas and information on nature photography. A gardening club could ensure that your students have some splendid subjects for still-lifes. (By the way, vegetable gardens are excellent locations for exploring light, line, shape and texture.)

If you're looking for a good place for students to practice candids, consider the local Bingo hall, the annual Shriners' parade, the Elk's weekly barbecue or whatever local events draw a diverse mix of people. (Be aware of the possible need for flashes in these settings.) Pay attention to local events calendars, bulletin boards and other sources of news on upcoming events and be sure everyone knows of your interest. With any luck, people will soon be seeking you out with ideas on new projects and events that may benefit your class and enable them to become active participants in your community's life. That is one way in which a course in photography can be expanded into a rich and multidimensional educational experience.

Etceteras

No list of this kind can cover all the educational opportunities that may be available in your own community. Some novel ideas will certainly present themselves once you begin exploring.

For example, if a college, technical school or university is within reach, you might be able to establish an ongoing relationship with its photography department, making arrangements for your students to sit in on classes, join in critique sessions and tour (or use) the darkroom facilities. Some recreational facilities are equipped with darkrooms and may be willing to make special arrangements for students to take advantage of them. There may be a local crafts cooperative or other similarly equipped organization that would rent darkroom space to your class at a modest rate.

If you're located near the offices of camera, film or accessory manufacturers — or custom labs, publishing companies and related businesses — then additional field trips and classroom presentations should not be difficult to arrange. Perhaps a printing company would provide a tour of its color-separation facilities (if it's big enough to have one), showing students how a photograph is prepared for printing. A television studio might offer a similar tour, showing how images are broadcast on TV.

If no such resources are close at hand, you might write to some manufacturers and request stock slide presentations or promotional literature. Tiffen, for example, offers an excellent presentation — free of charge — on their line of filters. The presentation (which runs about 30 minutes) comes with a loaned dissolve unit and tape player and even a filter "door prize." All you would need to provide is a Kodak or compatible slide projector and a screen. Call 800-645-2522 or write to Tiffen, 90 Oser Ave., Hauppauge, NY 11788 to make arrangements.

Kodak also offers an extensive range of promotional literature on their films, cameras, CD and computer imaging systems, etc. Use a touch-tone phone to call Kodak's product information line, 800-242-2424 and hit the appropriate buttons to find what you need.

You may also be able to join forces with other classes or groups in your own school. One obvious example is for your class to be actively engaged in producing the school yearbook. Another is to help produce promotional materials for a school play by photographing the actors in appropriate poses for a poster or hallway display. Don't forget the local newspaper as an outlet for this kind of work!

Some of the exercises in *The Photographic Eye* may suggest additional avenues for this kind of collaboration. (One specific example is the "Text & Image" exercise on pages 224 and 225 of the text.) A writing or English class might work with your photography students to develop an exhibit or

slide show on some topic of shared concern or interest. You might produce a similar presentation about your town with a history class, photographing buildings that are historically significant or doing copy photography of antique prints. A social studies class might be a good partner for a presentation on your community as it is today, possibly illustrating the various government offices and civic groups that are active in its daily affairs.

In short, once you start looking and asking, odds are you'll find more potential resources than you can possibly use.

PREPARING THE CLASSROOM

The ideal classroom for teaching photography is one that is reasonably spacious, well-lit and abundantly stocked with photographs. With a modest investment of time, money and imagination, virtually any room can be converted into a space that will facilitate the learning process and promote efficient working habits.

Basic Set-Up

Arranging the Furniture

A well-designed photography classroom will of course contain the usual desks and chairs, though you may wish to cluster them together (especially if their tops are flat and of uniform height) to create additional surfaces for spreading out photographs or supplies and to encourage students to interact in smaller groups. Off to one side, it is a good idea to clear a space for cutting mats and mounting prints. This area will ideally include a good paper cutter, a mat cutter and dry-mount press (if available), plus a large table to work on. Some surrounding floor-space will also come in handy, since many tasks can be done on that level.

The next major concern is preparing a suitable arrangement for critique sessions. The goal here is to devise an effective way of displaying photographs in full view of the entire class. This is often done by simply tacking photographs directly into the wall (assuming its surface is receptive and no one minds having it poked full of holes). Another method is to attach narrow strips of wood along one wall, on which mounted prints can be placed. An advantage to this approach is that the photographs can be easily rearranged. This permits exploration of the ways various individual images relate to others and produces interesting and instructive combined effects.

Whatever system you employ, it is very important that the crit area be free of additional clutter — an otherwise blank wall will help focus students' attention on the photographs and promote visual clarity. You will also want

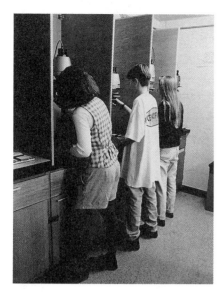

Ample space, effective light traps and fastidious cleanliness are essential ingredients of any shared darkroom space. *(Photograph by Dorie Parsons.)*

to arrange the classroom furniture so there is a clear passage along the whole length of the crit area, so everyone can get up close and observe details. One final consideration: the crit area should be set up out of reach of direct sunlight, as this will hamper visibility.

Light

Lighting is a matter of critical importance in any classroom devoted to the visual arts, especially for work done in color. If at all possible, avoid standard fluorescent lights (or low-wattage incandescent bulbs) as these will impede clear vision and impose an unfortunate "color-cast." (Fluorescent light produces a flickering greenish-blue effect that is especially hard on the eyes. Incandescent light tends to be orange, which is not much better.) Excellent full-spectrum bulbs are available for either kind of lighting. They are fairly expensive and may be difficult to locate, but are certainly worth the trouble. (Check at your nearest health food store if all else fails.) No other single expenditure is likely to have as much impact on the educational quality of your classroom as obtaining good lighting. It is very hard to learn to see well when one must struggle to see at all.

Decor

With the sole exception of the crit area, it is entirely appropriate to cover all available walls with photographs. One key to developing critical judgment in photography is to look at a large number of examples of other photographers' work.

Constant exposure to photographic excellence provides students with a standard for which they might strive. It heightens their expectations. Even less-than-excellent photographs are useful aids in developing visual acuity, though it is not productive to be surrounded by outright mediocrity. Changing the collection of photographs on your walls at regular intervals is one simple way of ensuring that your classroom is a dynamic environment, one that promotes interest, creativity and high aspirations.

Whatever other resources may be lacking, a collection of photographs is one resource that is absolutely vital and well within anyone's reach. Since budget limitations usually prohibit the purchase of exhibition prints, the primary source will be magazines and books. While it is highly recommended that teachers subscribe to one or more of the better photography magazines for class use, that is just the beginning. *National Geographic, Sports Illustrated, Islands, People, Time* and *Newsweek,* fashion magazines and a host of other periodicals contain numerous photographs that are well worth critiquing. Similarly, coffee table books on foreign countries, cooking, archi-

tecture and many other subjects are packed with striking photographs, as are travel brochures, annual reports, calendars (less expensive after January 1), posters and catalogs.

One good early assignment is to ask each student to scour the basement or attic at home for magazines and books with photographs that can be cut out and displayed. This exercise in itself is certain to prove highly educational and may provide a basis for fruitful discussion of the various branches of photography (scientific, sports, cultural, fashion, product, portraiture, photojournalism) and of photography's role in our culture.

In the unlikely event that this assignment fails to produce an adequate stock file, local civic groups, libraries, doctors' offices and other sources in the community might also be approached for their discarded books and magazines. This same approach could be a good way to obtain additional, if somewhat outdated, camera equipment. Virtually every photographer has an old lens, light meter or tripods gathering dust somewhere.

If some budget is available, inexpensive books may be found in the remainders bins at bookstores and even at yard sales. Barnes & Noble and other discount book distribution companies have mail-order catalogs offering suitable books at discount prices.

A well-equipped (and carefully designed) darkroom will enable a sizeable number of students to work together, without generating chaos or tedium. *(Photograph by Dorie Parsons.)*

The Darkroom

Every photographer dreams of the perfect darkroom, and most of us manage to make do with a merely adequate substitute. The main reason for this is that a first-rate darkroom is very expensive to build, equip and maintain.

Ultimately, however, there's only one thing that really matters: dust. If you can't keep dust under control, it will consistently sabotage your ability to teach good darkroom skills and undermine your students' efforts to produce high-quality prints. Nothing is more frustrating (and more damaging to a student's desire to learn) than spending hours in the darkroom laboring with painstaking care over a single print, only to discover a motley collection of white specks all over it once it's brought into the full light of day.

Knowing the importance of effective dust-control is one thing; achieving it is another. Here again (unless you are very lucky or endowed with a luxurious budget) you will probably have to accept some compromises. But you will have a distinct advantage if you recognize dust as your sworn enemy and vigilantly pursue it.

Begin by limiting the surfaces and nooks and crannies where dust can collect. Install no more shelving than you actually need (or remove whatever excess may already be in place). A good basic darkroom requires only a single counter top to support the enlarger(s), a large sink and enough space for processing trays (in the sink if it's big enough). Reduce clutter to a strict minimum. Store papers and all non-essential equipment (extra enlarger lenses, etc.) in file cabinets or any other available containers. Keep nothing in the actual darkroom space that doesn't absolutely belong there; cram the overflow into a closet somewhere else. It is perilously easy to let odds and ends begin to collect in a darkroom, so a periodic "spring cleaning" is highly recommended.

All surfaces should be non-porous, to ensure that chemicals — and dust — can be wiped away. (Uncovered concrete and wood are especially undesirable.) All cracks should be carefully caulked. This will also assist in controlling culprit number two: light leaks.

Light and dust traps should be installed along the edges of all doors (insulation kits available in any hardware store work fine). Any windows should of course be thoroughly blacked out and sealed shut. Linoleum is probably the best surface for the floor (again, avoid exposed concrete). Ideally, walls will be painted white (enamel or other easily cleaned paint is best), as this will make any residue more visible.

If the size and layout of your darkroom space permit, it is a good idea to construct a light baffle, so students can come and go without letting light slip in (disastrous for prints in progress and opened boxes of photo-paper). One reasonably simple procedure is to hang three or more floor-to-ceiling strips of black, opaque fabric (coated with plastic if possible) in overlapping

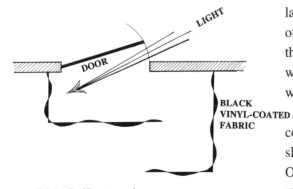

LIGHT

DOOR

BLACK VINYL-COATED FABRIC

Light Baffles, top view

rows, creating a passageway through which people can pass without bringing in light. If you must resort to a generic doorway, hang at least one light-trap strip about three feet into the darkroom, parallel to the door, attached to the wall on the side where the door opens (opposite the hinge). This will at least ensure that no blasts of full daylight spill in unannounced.

One common misconception is that a darkroom must be. . .well, dark. While it is true that prolonged exposure to even red or yellow "safe" lights can fog papers (and will certainly ruin film), a well-designed darkroom will have enough of these (carefully placed to provide illumination where it's actually needed) to ensure that it is not difficult to see once the eyes adjust. The desired effect is suggestive of twilight. There's no need to fumble about in true darkness, increasing the risk of mistakes and accidents.

At a minimum, each enlarger should be equipped with its own safe-light, and there should be two or three at intervals above the developing trays and sink, plus a general source of illumination for the rest of the room if it's large enough to need it. Be sure all switches are readily accessible, so lights can be turned on and off as appropriate.

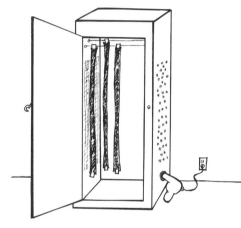

Film drying closet

You will also need to devise an entirely "light-tight" space for handling film. A closet can work fine for this. Just be sure the door, when shut, is fully sealed against light-leaks and you're in business. As an alternative, you can use part of your main darkroom when it is not otherwise in use.

An enclosure for drying film is another virtual necessity — and it must be both ventilated and impregnable to dust. Once dust lodges into the emulsion of wet film, it is maddeningly difficult to get rid of it. Prevention is the only real cure. One simple technique for constructing an effective film-dryer is to build a "box" out of plywood into which an array of holes has been drilled. It should be tall enough to accommodate the full length of a 36-exposure roll of film and sufficiently spacious to hold a day's output for the entire class without crowding. (Rolls of wet film will stick to each other if they touch, often with tragic results.)

The front can be a simple latched door. Cover the inside with some kind of fine-mesh cloth to keep dust from entering.

One option is to drill a larger hole (also mesh-covered) near the bottom into which the nozzle of a standard hairdryer can be inserted to speed things up. Finally, install a few rows of wire or string near the top onto which film clips (or clothes pins) can be clamped to attach the film.

Efficient use of affordable technology (such as this print-drying rack) can make the critical difference between frustration and enthusiasm.
(Photograph by Dorie Parsons.)

One other piece of standard equipment (which may not be immediately apparent in a school environment) is a radio. There's certainly nothing wrong with providing some entertainment to promote the idea of the darkroom as a fun place to work, but there is an additional benefit to musical accompaniment. Much of the time spent in a darkroom is devoted to waiting (for the chemicals to do their stuff, for a turn at the enlarger, for instruction or assistance, etc.) and boredom is always a factor that must be considered. The time passes very slowly in dead silence and this can lead to hasty work, which in turn produces sloppy results. If you prefer not to promote rock-and-roll, tune in to a good classical station and introduce your students to some serious culture. Or perhaps you have an all-news station in your area which can keep your students abreast of world events. (This is one small way in which photography can be linked to other areas of education.)

As for equipment, a reasonable wish-list will include the following:

1. As many serviceable enlargers as you can afford or otherwise obtain, within reason. Two or three should be adequate for most class sizes. More than that may simply invite pandemonium. One may be enough if you structure your class accordingly, but this will reduce opportunities for convivial co-learning. (However, with a bit of patience, two students should be able to share a single enlarger without undue difficulty.) Plan to allow about four square feet of surface space for each enlarger, which leaves room for contact sheets, negatives and other paraphernalia.

2. One full array of developing trays for every two enlargers. Anything less is likely to result in bottle-necks and/or confusion. Bear in mind that exposed prints can be stored (save the black plastic liners from photo-paper packaging for this purpose) and batch-processed to assist in controlling the flow of darkroom activities.

3. Two timers for each enlarger — one for exposure and one for keeping track of processing times. Inexpensive stop-watches are perfectly acceptable for the latter.

Additional equipment and supplies are outlined in Appendix 1 ("Processing") in the text. These include developing tanks for film processing, tongs, film cleaners, tools for dodging and burning (which can be handmade), spotting inks and an ample stock of chemicals and paper. In addition, be sure to have extra enlarger bulbs on hand to replace any that burn out.

If you're on a tight budget, keep your eyes open for bargains in newspaper classifieds, bulletin boards and yard sales. Enlargers, especially, tend to last a long time and there's an excellent chance that you'll find a trusty old model just waiting for a new home. (One note: avoid glass negative carriers — they're very hard to keep clean and tend to scratch film if not used properly.) You might want to run an ad yourself or post billboard notices to alert local photographers to your needs. And, as always, check out any stores dealing in second-hand photography equipment — let the proprietors know what you're looking for so they can help you find it.

You might also be able to work out a favorable deal with a photo lab for slightly out-dated paper. With luck, it will still be fully usable and could save a substantial sum of scarce money.

Ventilation

Professional photographers recommend general ventilation with ten air changes per hour for the darkroom. In other word, to dilute the contamination from chemicals normally in use, fresh air must be brought into the room to replace the old air ten times during every hour. Some ventilation experts feel this "rule of thumb" is inappropriate in many uses and is a difficult concept for a teacher to use. Three steps should be taken to determine what constitutes effective ventilation. First, gather all possible information about the chemicals used in the darkroom, including the amount to be used at any one time. Second, collect information on appropriate ventilation systems and recommended standards. Third, take that information to the school's personnel responsible for maintaining school ventilation systems. Get that person to apply the information to your specific room. This is not a job for the teacher alone.

Defraying Expenses

No matter how one approaches it, photography is a relatively expensive art medium. If students can all afford or otherwise obtain cameras, one major hurdle will be cleared. If not, it may be necessary to provide one or more "class cameras." The same might apply to a tripod and a few other accessories. In addition, there are the costs of darkroom equipment, film, paper and chemicals. Depending on circumstances, the school may underwrite all of these expenses, the students may be expected to cover the full amount themselves or something in between.

Fortunately, if funds are limited, photography offers a number of fund-raising possibilities.

- A local camera club or civic group might be approached for contributions of money or equipment.
- Exhibits might be held — perhaps in a private gallery, civic center, town hall, store, museum, church, Y or library — with a modest fee.
- Prints, especially those in an exhibit, can be offered for sale. A standard minimum for pricing prints is to triple the total cost of supplies.
- The class might produce an annual calendar to sell in the community, perhaps featuring local highlights. (The Chamber of Commerce might be persuaded to buy copies in bulk.)
- Greeting or note cards, postcards or posters might be produced and sold, perhaps with the assistance of a local printer willing to print them at cost. (This is especially feasible if the printer uses excess paper from other printing jobs.) Perhaps the school has a print shop that can handle the job, or an art class that can produce silk screen prints.
- Perhaps a black-and-white book of student work can be published and marketed in conjunction with an art class.
- A camera might be raffled at some community function.
- A portrait booth might be set up at a school carnival or town fair or on the street at any time. (Lights could be set up if needed, portraits photographed, prints delivered later.)
- Advanced students might even hire out on behalf of the class to cover weddings or parties for a fee. (Legalities and local sentiment should be checked first.)

part 2 Planning the Course

Naturally, how you structure your course will vary according to resources, class schedule and other factors. The course on which this text is based meets once a week. Each class begins with an explanation and discussion of the next assignment, followed by a critique session. Students are expected to complete the assignment, including darkroom work, on their own.

Early in the fall, give each student a list of all assignments for the year. This offers students a sense of the structure of the course and enables them to keep an eye out for future assignment subjects. Naturally, some flexibility is maintained to accommodate unforeseen opportunities or obstacles, such as an exceptionally photogenic snowfall or a long stretch of rainy weather that forces students to work indoors.

Prior to each class session, relevant samples are displayed to stimulate ideas. (As mentioned earlier, a simple rack consisting of wooden strips attached to the walls would facilitate this and the critique sessions.) Once the class is in session, the teacher summarizes the exercise, covers any logistical details (field trip schedule, for example, if one is planned for the assignment), discusses the displayed samples, and notes any "idiosyncrasies" (lighting considerations, possible locations, potential problem areas, special equipment, etc.).

STUDENT ROLE

Students are required to shoot one roll of 36 exposures — entirely devoted to the assignment — per week. A general rule for assignments is: the more specific, the better. Most students will want very clear guidelines, at least at first. The more creative students won't need that — they'll be creative anyway. The primary goal of the assignments is to focus students' attention on subjects they might otherwise overlook. This trains their photographic vision and gets the process of "learning to see with a camera" going much more quickly than with a more *laissez faire* approach. In addition, having students work on the same assignment at the same time makes critique, or "crit," sessions easier and more beneficial. It's very important, therefore, that students do shoot what is assigned. (You might point out that if an assignment were from a client, they'd have to get the right shot or lose the job.)

Once the next assignment has been clearly presented, the students turn in their finished prints from the previous assignment. All prints are required to conform to a standard format. First and foremost, they must be a full 8" x 10" (20.3 cm x 25.4 cm), no elongated shapes, which imposes a healthy compositional discipline. They must be mounted on some appropriate cardboard stock, so they won't curl or fall over during crits, and trimmed flush with the edges of the print (no borders). You may settle on a different standard, such as white, 1-inch (2.5 cm) borders on all sides, but it is important that a clear standard be established. This is both good training and an important means of equalizing factors that might influence judging (such as the presence or absence of borders).

CRITIQUING

The prints are arranged — anonymously — at random along the wall, in full view of the entire class. Students are then called on to discuss value, focus, presentation and other technical issues (one photo for each student).

Once each has been discussed, students take turns arranging the photographs from most successful to least successful, as follows:

- The first student called on selects what he or she considers the most successful print and places it at the head of the line.
- The second student selects the second-most successful print and places it next in line. Each student may overrule any previous selection as well.
- This continues until all the prints have been ranked.

Crit sessions offer an opportunity for students to express their perceptions of each others' work — promoting clarity, objectivity and camaraderie.
(Photograph by Dorie Parsons.)

An alternate approach is to approach both ends of the line at once, with the first student selecting the most successful, the second student selecting the least successful and so on. Either way, discussion is encouraged at all times, so the final sequence reflects the class consensus.

One good rule is that each opinion must be substantiated (citing composition, presentation and so forth, not merely "I like it"). It is very important that students understand early that liking or disliking the subject matter is not an acceptable basis for a critique — each photograph must be judged on its *photographic* merits. It is equally important, though more difficult, that students understand that the purpose of the crit is to learn — the criticism is not a personal attack. All students should be learning from total crit: getting ideas on what to do and not do in the future, rather than merely waiting for judgment on their own efforts.

Anonymity is essential. At first, students generally have a hard time criticizing their own work or that of their friends. Most will find it much easier to do this if they don't know whose work they are discussing.

Once the students have determined a sequence, the teacher goes through the same procedure. (The same rules should apply: substantiate on photographic grounds.) This may result in a very similar arrangement or in a substantial re-ordering. The grades are then determined and written on the back of each. Though grades are not generally announced, students will have some idea of how they've fared by their position in the final sequence.

Teacher Evaluation

The authors feel that grading is very important. Done wisely, it promotes a healthy degree of competitiveness and competition fuels effort. In order for grading to be fair and productive, it is vital that the teacher be clear about what the criteria will be for each assignment, as well as what criteria apply to all assignments. Grading should, we feel, be reasonably strict. Be direct and honest.

Photography, like any art, easily degenerates into self-indulgence, if allowed to do so. If high standards are not set, they won't be achieved. No student benefits from the false comfort of being graded higher than his or work deserves. This is especially true for any student who hopes to pursue photography professionally. The people who pay for photography are not noted for their gentleness.

Though some intuition will of course come into play in making your final judgment, each grade should be largely based on objective criteria: quality of the print, accuracy of focus and exposure, care in composition, inclusion of important elements and exclusion of distractions, appropriateness to assignment and so on. Teachers are urged to be on guard against the inherent dangers of imposing one's own tastes on the class. It's a difficult trap to avoid. One key is to remain mindful of the distinction between style (what one likes) and standards (what is well executed). Standards are the proper domain of teaching and judging, a personal style cannot be taught and ought not be penalized.

Our recommended guidelines for grading are as follows: any photograph that meets all the basic requirements should rate a "B." A few shortcomings might drop it to a "C." A disaster, especially a sloppy print, might deserve a "D." A photograph showing no serious effort should be stuck with an "F." A grade of "A" should be reserved for that extra margin of inventiveness, insight or impact. An "A+" should be reserved for a really special achievement. In practice, not every crit will yield an "A." Sometimes there will be two or three. Use them sparingly so they mean something.

Students who do poorly on a given assignment are entitled to redo it at any time during the term, to improve the grade. This provides valuable incentive and helps to correct for the risk of teacher misjudgment. Periodic "make-up" crit sessions are scheduled, in which all the redone assignments are critiqued together. When transferred from the photos to the grade record, grades are recorded in pencil to they can easily be changed. In addition, students are encouraged, though not required, to submit more than one print for each assignment. Only the highest grade received for that assignment is recorded.

Prior to each crit session, the teacher reviews each student's contact sheet(s) to help select frames to enlarge. When a print is turned for a crit, it must be accompanied by contacts and test strips, so the teacher can talk about what has been done well, what might have been done differently and go through all possibilities of what went wrong (assuming something did).

At the end of the term, the teacher selects a set of, say, six photographs by each student for the class "library." This builds stock files for future use.

STUDENT PORTFOLIO

At the end of the year, each student is required to produce a portfolio of his or her best work as a final project, which may or may not be graded. Thus, each student retains a permanent record of his or her photographic accomplishments, which in some cases will lead to the start of professional work. (An impressive portfolio is an absolute requirement for anyone wishing to launch a photographic career.)

As the class progresses, students may be given a looser rein on assignments. We recommend against settling into a "do what you want" mode, however. One essential for competent photography is the ability to go out and find what one is looking for. Without some structure, it is all too easy to fall back on one's lazier predilections, doing what comes easily, rather

than continually striving to break new ground. One alternative to assignments from the teacher is to let each student commit in advance to a topic or theme and then go out to photograph it. This leaves considerable room for individual interests, while preserving a coherent structure and clear expectations.

CLASS VARIATIONS

There are a number of ways to adjust this core class structure according to your particular circumstances. If your class meets five days a week, you might "double up" with two assignments and two crits per week — though this may be too demanding. Alternatively, you might schedule, say, crit sessions for Monday, an assignment shooting session (many can be conducted in or around the school building) for Tuesday, research projects for Wednesday, darkroom work for Thursday and critiques of other photographers' work for Friday.

If your darkroom facilities are limited, you might organize the class into several groups, having one group use the darkroom while another is doing research or crits. If so, we recommend re-organizing the groups at intervals, so more advanced students can help others. If you also teach other art classes, you might arrange for groups of two or three students to use the darkroom, during other periods. If you don't have access to a darkroom at all, you can make do without one, thought this will add to the expense and diminish the learning experience. Perhaps raising money to purchase darkroom equipment — through exhibits and sales of class photographs — could become a collective project.

Other possible variations include:

- using class time to mount prints, making extensive use of the "cropping exercise" (in Chapter 3 , page 65), either privately or in front of the class.
- arranging for a drama class to provide models (perhaps in stage dress).
- concentrating on playground activities if the photography class coincides with an elementary recess.
- having photography students take an active role in producing the yearbook (as already noted), perhaps doing senior portraits as well as candids and sports photography.
- mounting periodic exhibits, possibly on an exchange basis with other schools.
- taking field trips on foot in the school vicinity during class periods.

You may want to make extensive use of exercises which can be undertaken in the classroom without requiring additional photography, such as "Photo-Copy Photos" (page 221 of the text) or "Text & Image" (pages 224 and 225). You can develop your own exercises for print manipulation, using markers, photo-tints or other media to embellish existing photos. Or, try photo-collage, mounting fragments of several prints together to produce a composite image.

RESEARCH PROJECTS

The amount of information students learn independently and from each other can be vastly increased through creative use of research projects. Rather than merely assigning topics for papers that serve no function other than to effect a student's grade, use this work to benefit the entire class.

For example, students might be asked to research various topics (perhaps selected from a list of options) and then to take turns sharing what they've learned by presenting their findings to the class as a whole. They might then move on to another topic, report on it, and so on throughout the year.

Here is a brief list of possible topics:

- profiles of important past and present photographers or periods in photographic history (refer to chapter 1 for ideas)
- styles: the "decisive moment," pictorialism, landscape, photo-montage.
- specialties: photojournalism, portraiture, sports, advertising, fine arts, science (again, refer to chapter 1).
- technology: stages in the evolution of cameras; film and other tools; film processing; the future of photography; the mechanics of the camera or lens; flash; how light reacts with film; reciprocity failure; auto-focus.
- technique: the Zone System; studio lighting; flash fill; action photography; night photography; infra-red; special effects.
- interviews with local photographers
- product research on different brands of cameras, lenses, flashes, filters, tripods.
- reviews of books and magazine articles on photographic techniques, compilations of work by individual photographers or thematic collections such as the *A Day in the Life of. . . (Hawaii, Spain, Canada, Japan,* etc.) series by David Cohen and Rick Smolan, published by Collins SF.

- "rainy-day" activities, such as constructing a pin-hole camera, producing photograms or manipulating Polaroid prints (which produce interesting effects if scored with a stylus during the development process).
- the specific chemical processes that produce an image on photographic film and paper. What is the developer actually doing? The stop-bath? The fixer? What happens, on a molecular level, when light strikes the film? What are the components of color film and how do they work? This can also lead to such basic questions as how our eyes enable us to see and how our brains translate a two-dimensional image into a perception of a three-dimensional scene. (There are actually some cultures in which a photograph is incomprehensible, because their brains have not been trained to process images in this way.)

Some topics will lend themselves to a traditional essay or book report format, which may be read aloud or photocopied to serve as the basis for discussion. Others, such as specialized or advanced photographic techniques, will open opportunities for more interactive demonstrations.

For example, one or more students might be given an assignment to research infrared photography, compiling basic information on films and filters, locating some samples and, ideally, producing some examples of their own. They might then provide basic instruction to the rest of the class in preparation for an infrared exercise in which everyone participates.

Something similar might be undertaken for studio lighting. Arrange for a group of students to spend some time in the studios of local photographers, learning the basics. They might then present a demonstration that could lead directly into a new exercise (again with full class participation), possibly using equipment borrowed from (and supervised by) their sources.

An exciting further development of this concept is for one or more students to prepare a "briefing" on a controversial topic, which would then be discussed by the entire class.

Suggested topics for this purpose include the following:

- environmental concerns regarding the production and disposal of photographic chemicals
- social issues such as the invasion of the privacy of celebrities (i.e., the notorious *paparazzi*)
- the use of photography in generating public awareness or shaping perceptions of wars and other world events
- the evolution of presidential "photo-ops" and their effect on the quality of news reporting

- the moral and ethical implications of using photography to investigate indigenous cultures (some of whom have objected strenuously, regarding the camera as a "soul stealer")
- other moral and ethical dilemmas that photographers may confront, such as: "You are a photojournalist covering a war (or a presidential campaign, a celebrity wedding or a crime scene); is there any situation in which you would not do your job, even if it meant missing a major scoop? How far would you go (in terms of invading privacy, for example) to get the shot you want?"
- the conflicting aesthetic views and methods of, say, Ansel Adams and Diane Arbus or any other pair of photographic "schools of thought." (Photographers are a wonderfully opinionated lot!) You might even assign each student to research the views of a single noteworthy photographer and then have them assume this persona (like characters in a play) for a debate or panel discussion. ("Mr. Adams, how would you evaluate the work of Cartier-Bresson?" "Ms. Arbus, would you care to comment on last week's cover of *Time* magazine?")

A similar approach (minus the specific characters) could be applied to the "moral and ethical dilemma" questions as well.

- What is the "right" kind of camera? automatic vs. manual?
- Is there a future for photography? If so, what will it be like?
- Is photography an art?
- Is a photograph a true record of a scene or event? Can photographs lie? Can they distort the truth?
- Is it true (as the singer Paul Simon once observed) that "everything looks worse in black-and-white," and (if so) why? Does everything look better in color? Again, what might cause this impression? Does this have an effect on the truthfulness of photographs? Does it matter?

Once you begin exploring these dimensions of photography, you will no doubt discover that the list of possible topics meriting discussion is virtually endless. By challenging students to actively consider the implications of photography (and its potential for misuse) you may vastly expand the horizons of their awareness — transforming a course in photography into a wide-ranging exploration of the nature of life and the hard choices we all encounter. More practically, you can also use photography as a framework for a host of related activities bearing on subjects as diverse as writing, public speaking, science, social studies, history and even drama.

EXERCISE VARIATIONS

As already noted, virtually all of the exercises in *The Photographic Eye* can be expanded and revised with any number of variations. This may serve at least three useful functions. First, it will enable you to pace the course according to your own design and your students' aptitudes and interests. If one area of activity proves to be especially engaging or troublesome, you can increase the amount of time devoted to it by employing some of these potential variations. Second, you may wish to broaden the scope of any particular exercise by offering variations as additional options. This will allow more experienced or gifted students to forge ahead to new levels of challenge and fulfillment, while allowing novices (or those to whom photography poses special difficulties) time to catch up. Finally, in some instances variations can be employed to narrow the focus of an exercise, either to provide more detailed instructions or to demonstrate the range of possibilities contained within any single theme.

It is vitally important in any course of this nature to provide plateaus at which students can experience a sense of competence and savor the rewards of mastering a set of skills before proceeding into the dark waters of renewed uncertainty. A constant barrage of daunting assignments will only result in emotional fatigue and discouragement — and too long a respite may induce boredom. Naturally, students will experience these two extremes at different times. Incorporating a degree of flexibility within your course structure will help them establish a productive rhythm of challenge and accomplishment, ensuring that each student's individual "learning curve" is neither too abrupt to be manageable nor too gradual to be consistently engaging.

The chart on the following pages suggests a number of possible variations on exercises contained in *The Photographic Eye*. You will no doubt discover others that are specific to your situation, skills, experience and priorities.

These examples convey the general idea of the "variations" concept. Some exercises in the textbook also include additional variations or present a number of options. You may wish to adjust these when you discuss actual assignments with your class, adding or subtracting as appropriate.

TEXT PAGE	EXERCISE	THEME	VARIATIONS
p.100, 101	Leaves	texture	rocks, building materials, tree trunks, vegetables
p.110, 111	Circles & Ovals	shape	rectangles, tools, branches, fences, windows
p. 127	Bracketing	lighting	deliberate over- or under-exposure (shoot a roll of film at half or double the recommended ISO and see if any desirable effects are produced as a result.)
p. 134, 135	Blurred Motion	shutter speed	"slow-speed/low-light"*: shoot at 1/15 of a second or slower in low-light situations with a hand-held camera, deliberately using "camera-shake" as an asset.
p. 146, 147	Point of View	perspective	"random shots": shoot a roll without looking through the viewfinder
p. 154, 155	Bicycle	multiple views of a single object	chair, house, tree, TV, door, cardboard box, fire hydrant
p. 156, 157	Hubcaps & Taillights	details	architectural close-ups, houseplant (w/macro lens), sidewalk, train tracks
p. 158, 159	Eggs	light and form	a handful of pebbles, marbles, apples and oranges, chessboard
p. 160, 161	Object & Shadow	compositional use of shadows	shadows only
p. 162, 163	Bottles & Glasses	translucence	glass of water, prism
p. 164	Water	moods in nature	clouds, sunlight, weather, wind, fog, dawn
p. 165	Old Things	character in objects	high-tech, toys, "favorite things"

*Topics in "quotes" indicate either specific techniques or exercise titles that are intended to provoke interpretation.

TEXT PAGE	EXERCISE	THEME	VARIATIONS
p. 170, 171	Landscape	natural environs	mountains, stream, "wasteland," "oasis"
p. 172, 173	Architecture & Environment	public spaces	"ruins," miracle mile, "commons" (as in parks and town greens)
p. 174, 175	Neighborhoods	sense of place	backyard, main street, "room with a view," home, bus depot
p. 176, 177	Zoo/Farm	non-human subjects	birds (w/zoom lens), "comparative dogs and cats"
p. 178	Store Windows	insights into common sights	cars, stairs, doors
p. 179	Construction Sites	random sources of line and pattern	"curves," "square and circle," etc.— all in public spaces
p. 186	Hands	"body parts"	feet, noses, lips, eyes
p. 187	Elders	qualities of specific groups of people	farmers, pedestrians, families, parents, brothers and sisters
p. 190 p. 191	Soft-Light and Side-Lit Portrait	effect of lighting in portraiture	low-light portrait, over-exposure portrait, light and shadow portrait
p. 192	Prop Portrait	use of objects to evoke personality	"object portrait": use objects only (no person) to convey subject, shoes, hats, car and driver
p. 194	Detail Portrait	portraits without faces	(see "Hands" above), legs in motion, gestures, backs
p. 195	Mood Portrait	varieties of expression	"1 subject, 1 roll": shoot an entire roll of 1 person in a single session, curiosity, joy, waiting, "oops"

*Topics in "quotes" indicate either specific techniques or exercise titles that are intended to provoke interpretation.

RETEACHING OPTIONS AND PRODUCTIVE PLAY

For those students who encounter difficulties with any aspect of photography, you may find it helpful to consider alternate approaches to teaching the requisite skills. One way to start is to look beneath the surface and strive to locate any underlying causes which may not be immediately apparent.

For example, one potential problem area that all photographers must confront to some degree is a high level of interaction with others (often total strangers) which can be extremely uncomfortable and — until identified — may be the source of an otherwise inexplicable inability to capture effective "people pictures." Creating a safe environment, such as encouraging the use of friends and family members for "set-up" shots, may be all that is necessary to solve this dilemma. Extensive use of self-portraiture may be another useful approach to try, especially for highly introspective students who may lack effective social skills.

Others may have a hard time grasping the core concepts of composition. In this case, you might try some special exercises in which you work with the student (or class if this is a generalized obstacle), experimenting with a collection of visually interesting objects (an assortment of fruit, blocks of wood or odds and ends gathered in the classroom). Using a combination of addition, subtraction and rearrangement, discuss the way each change affects the "image" (which may be viewed through the mat frame explained in chapter 3), as you seek to draw out the student's responses. With creativity and patience, this process can often stimulate an exciting "click" of recognition, when a student suddenly sees how composition works. If the use of three-dimensional objects proves unproductive, try the same approach using cut-out shapes of black paper (with a bit of Spray Mount™ on the back of each) to produce various compositional effects on a white mat board. (For best results, enclose the image area in some kind of frame.)

For a more dynamic approach, consider creating a "virtual camera," consisting of a cardboard box set on its side on a table, with the top and bottom removed to produce a limited field of vision (approximating the frame of a viewfinder or print). One or more students may be asked to arrange objects within this frame, then step behind it and observe the results. Alternatively, students could take turns being the "photographer" with the "camera" aimed at three or more other students who act as models by moving, standing and sitting as instructed. Or you might begin with a random grouping and then ask a student to change the position of only one of the subjects. The next student in turn might then be called upon to make one more change, and so on until an effective composition has been achieved. Yet another alternative

is to have students take turns shifting the position of the camera. In all cases, the effect of every change should be explained and discussed.

The goal of this sort of creative play is to promote an appreciation of the inherent fun of looking at the world through a camera, while freeing students of the burden of producing an actual photograph.

If you feel that some students consistently "freeze" when confronted with this daunting prospect, you may be able to loosen them up with a number of exercises designed to prevent "over-thinking" their photographs. These are similar in purpose to the timed sketching drills (or gesture drawings) often used in conventional art classes.

For example, have each student load a roll of film into a camera, assign each of them a subject (either another student or an object that is large enough to allow for a wide-range of angles). Then tell them they must shoot the entire roll in, say, two minutes — and begin counting. In their haste to meet this imposed deadline they are likely to forget their inhibitions and they may very well produce their first exceptional photographs as a result. At the very least, they will have a roll of film to process and will probably be curious to see the results, which is an excellent first step.

A variation on this theme (included in the "variations" chart) is to have students shoot randomly, without looking through the viewfinder. A time limit may again be useful. Or you can play a version of "Red Light, Green Light," instructing students to run around some visually interesting location (the classroom, if there is sufficient light or a nearby park or some area of town where there is no risk of encountering traffic). At your command, they must stop and take a photograph before you count to three.

A more elaborate extension of this theme is for you to set up a sort of photographic obstacle course: a series of casually arranged objects at some distance from each other, which students must race against the clock to photograph (possibly being required to rearrange each set of objects prior to shooting). The student who completes the circuit in the shortest time wins.

With any of these drills, by distracting attention away from the formal concerns of composing an impressive photograph, you will facilitate an uncontrived immediate response that can break up the mental logjams that inhibit free expression. In addition, this kind of kinesthetic activity involves a student's whole body in the photographic experience and introduces a vital spirit of play, both of which may help to overcome inhibitions and performance anxieties.

An altogether different and complementary approach is to slow the process down and simplify it so extremely that the tendency to see only the obvious cannot be sustained, which can also serve to open the doors of creativity. For example, select an open space outdoors and place your students

far enough away from each other to avoid distractions. Tell them they must stay where they are for 36 minutes, shooting one entire roll of film during that time at one-minute intervals (which you signal for them). They may stand, sit and turn around, but must not otherwise move. They may not photograph the same view twice. The goal is to produce as many different kinds of photographs as possible and they will be graded only on this basis: three points for each frame on a contact sheet (there's no need to make prints of them all) which does not repeat any other frame on the roll. The same approach can be applied to a single object, in which case students may move about freely but must shoot every frame of that one object from a different perspective.

Yet another playful option is a variation on "treasure hunts." Draw up a list of common objects or sketch various shapes and instruct students to locate and photograph each one within a specified time. This may be refined in any number of ways specific to any stage of the course. For example, you might simply instruct students to photograph as many different shapes (or textures or lines) as possible within a specified time on a single roll of film. Or you might assign a list of photographic categories: black-on-white, gray-on-gray, motion, detail, shadow, texture, etc. This last exercise is an especially efficient means of conducting a capsule review, which can serve as a useful reminder of photographic elements which students may have begun to neglect.

By using any of these methods to "circle back" to previously covered ground, you can accomplish the goals of reteaching students in need of special assistance without separating them from the rest of the class, as all students should find these exercises entertaining (at least) and possibly highly instructive. Returning to basics in this manner can provide a reassuring sense of progress, provide the sort of plateau experience mentioned above and promote awareness of the ways in which the various elements of photography are integrated and interwoven. At the same time, students who have lagged behind in certain areas can painlessly reprise them and may, in the process, come to understand concepts or develop skills that were previously missed.

Useful Information

HEALTH AND SAFETY GUIDELINES

Tools and Equipment

> *Always* be mindful that a paper cutter is a very dangerous tool. Use it carelessly and you could lose a finger. Never leave the blade up after use. Always look before you cut, to be sure no part of you, your clothing or anything else you don't want to cut is in the path of the blade.

Fortunately, photographic hardware is generally quite benign, posing few safety hazards. The only truly dangerous piece of equipment likely to be used with some frequency is the paper cutter. The note at left, which appears in the textbook in regard to paper-cutter use, should be strongly emphasized.

Outside of that, the most likely risk to health and safety is carelessness while photographing. Any photographer with one eye glued to the viewfinder and the other shut tight is at best half-blind. It is not uncommon for one to be so intent on getting the composition just right that a ditch or step or cliff or passing truck is blithely ignored until too late. (Those jokes about "one more step, one more step, splash!" have a serious side.) Students should be encouraged to learn good habits in this as in other aspects of photography. An advisable basic rule is: look around with both eyes before you peek through the shutter. This is as helpful for good composition as it is for avoiding bruised and broken limbs: scanning the environment without the camera gives a photographer a sense of bearings that will produce better photographs as well as prevent accidents. Under no circumstances should one walk in any direction without first checking to ensure that the coast is clear.

Chemicals

A student examines a newly processed roll of film. *(Photograph by Dorie Parsons.)*

The necessary use of chemicals in photographic processing does present some potential health and safety concerns. However, by taking proper precautions and promoting careful work habits, these concerns can be effectively minimized.

The fumes of many photographic chemicals may irritate the eyes, nose or lungs, cause headaches and other symptoms, and ultimately pose serious health risks. The most important preventative step is to ensure that the darkroom space is adequately ventilated (see "Ventilation" on page 21). In addition, all spilled chemicals should be cleaned up immediately and students should be prohibited from spending more than one hour in the darkroom without a "fresh-air-break." Splashing chemicals into the eyes is the most common potentially hazardous darkroom accident. Encouraging students to move slowly and deliberately when processing will aid in prevention. Should such an accident occur, the eyes should be immediately and thoroughly flushed with clean water and/or a sterile eye wash solution. It's a good idea to have a well-stocked first aid kit, just in case.

Prolonged contact with some chemicals (especially those used in sepia toning and other advanced procedures) may irritate the skin and/or result in rashes or discoloration. Though the most circumspect solution to this potential problem would be to insist that students wear gloves at all times in the darkroom, many teachers deem this unnecessarily cautious. At the very least, students should be strictly required to wash their hands thoroughly (with industrial-strength soap) after every darkroom session—and to use tongs (not fingers!) to transfer prints in and out of developing trays. (You should, however, have at least one back-up pair of gloves for students with allergies or sensitive skin.)

Other general precautions that should be strictly adhered to include the following:

1. Do not heat chemicals. Re-mix with hot water (or place container in a hot-water bath) if you need to raise the temperature.
2. Store chemicals in tightly sealed containers. In addition to reducing the risk of accidental spills and unnecessary fumes, this will significantly prolong the life of your chemicals. The use of specially designed, flexible plastic containers that can be compressed to expel excess air is highly recommended. Glass jars are *not* recommended: They can become very slippery in the darkroom, increasing the ever-present risk of breakage.
3. Do not use old chemicals. Unlike other supplies, such as paper and film, chemicals should not be used beyond their listed expiration dates. Doing so merely invites increased health and safety risks.

4. Carefully read and follow all safety guidelines provided by a chemical's manufacturer. Some photographic chemicals pose particular health risks that will be fully explained on the packaging. Make a habit of reading all the fine print before using any new chemical—and discuss all relevant information with your class.

Toxic Chemicals to be Avoided in the School Photo Program[1,2]

Chemical	Hazard
Developers	
Catechin catechol pyrocatechol o-dihydroxybenzene	Difficulty in breathing: cyanosis, liver-kidney damage; ingestion may be fatal
Pyrogallic acid pyrogallol	Cyanosis, anemia, liver-kidney damage; ingestion can be fatal
Diaminophenol hydrochloride	Severe skin irritation, bronchial asthma, gastritis, convulsions, coma.
Intensifiers	
Mercuric chloride	Chronic mercury poisoning.
Mercuric iodide	Chronic mercury poisoning.
Potassium cyanide	Rashes, chemical asphyxia; ingestion can be fatal.
Uranium nitrate	Skin corrosion, liver-kidney damage, radioactive.
Toner	
Thiourea	Causes cancer in rats; suspected carcinogen.
Miscellaneous	
Formaldehyde	Sensitizer causing respiratory and skin allergies; suspected carcinogen.
Freons (fluorocarbons)	Respiratory irritations; heating may produce poison gases.

[1] Seeger, *A Photographer's Guide to the Safe Use of Materials,* pp. 29-40.
[2] McCann, *Artist Beware,* pp. 310-324.

Photo Processes to be Avoided in the Schools[1,2]

Teachers must individually make decisions concerning these processes, but their use is not recommended because the potential hazards are so serious that controlling them is expensive. If a teacher has a special interest in one of the processes, it is suggested that after becoming fully aware of the potential hazards, the use of the process be kept the teacher's own personal creative work and not attempted with students.

Material Safety Data Sheets

Some manufacturers provide Material Safety Data Sheets (MSDS) for some or all of their products. The MSDS provides important safety information, such as a listing of all standardized ingredients and warnings regarding potential fire, chemical and personal injury hazards.

You should request a MSDS for any art material whose uses or characteristics are unfamiliar to you, any unlabeled material whose label does not provide warning information.

Process	Rationale for Avoidance
Color processing	Many of the chemicals used in color processing are highly toxic and require local exhaust and very careful control methods. It is a complex, difficult process and should only be undertaken in the most advanced classes under the direction of extremely well qualified instructors.
Cibachrome	Highly toxic chemicals used in this process are suspected especially of affecting the female reproductive system, possibly resulting in birth defects and miscarriages.
Gum printing	Requires local ventilation; dust masks must be worn when using powders. Results probably do not warrant the precautions necessary.
Cyanotype	Exposure by carbon arc light on potassium ferricyanide can release hydrogen cyanide gas. Eyes and skin are especially sensitive to UV radiation. Can be done safely if exposure is by sunlight and water is used for developing.
Daguerreotype	Exposure to highly toxic mercury vapor is possible; educational results do not seem to warrant the risk.

[1] Seeger, *A Photographer's Guide to the Safe Use of Materials.*
[2] McCann, *Artist Beware.*

18-Week Curriculum

Note: Items in parentheses are options that may be added to (or substituted for) basic objectives and schedule, or covered incrementally throughout the course (i.e., chapter 1 might be assigned for reading over a week or two possibly followed by independent research by each student on a selected topic).

WEEK 1

Topic: Introduction

Goal: Orientation

Objective(s): Outline schedule and procedures

Review basic camera functions

(Survey history and applications of photography)

Chapter(s): (1), 2

Class: Camera Demonstration

WEEK 2

Topic: Composition

Goal: Establish fundamentals of good composition

Objective(s): Introduce standards and vocabulary of composition

Practice crit procedures

Chapter(s): 3, 4

Class: Mat & Cropping Exercises, Sample Crit

Topic: Shooting & Processing

WEEK 3

Goal: Begin taking and processing photos

Objective(s): Apply "point of departure" settings

Expose and process a roll of film

Chapter(s): 5, Appendix 1: Processing Film & Prints (B&W)

Class: Demonstration of processing (Field trip to shoot 1st roll)

WEEK 4

Topic: Line

Goal: Explore use of line in photography

Objective(s): Shoot/process 1 roll of "line" subjects

Chapter(s): 6

Class: Crit, shooting session, lab work

WEEK 5

Topic: Texture

Goal: Explore use of texture

Objective(s): Shoot/process 1 roll of "texture" subjects

Chapter(s): 7

Class: Crit, shooting session, lab work

WEEK 6

Topic: Shape

Goal: Explore use of shape

Objective(s): Shoot/process 1 roll of "shape" subjects

Chapter(s): 8

Class: Crit, shooting session, lab work

WEEK 7

Topic: Light

Goal: Explore use of light

Objective(s): Shoot/process 1 roll of "light" subjects

Chapter(s): 9

Class: Crit, shooting session, lab work

WEEK 8

Topic: Motion

Goal: Explore use of motion

Objective(s): Shoot/process 1 roll of "motion" subjects

Chapter(s): 10

Class: Crit, shooting session, lab work

WEEK 9

Topic: Perspective

Goal: Explore use of perspective

Objective(s): Shoot/process 1 roll of "perspective" subjects

Chapter(s): 11

Class: Crit, shooting session, lab work

WEEK 10

Topic: Things

Goal: Practice photographing objects

Objective(s): Shoot 1 roll of still life subjects

Chapter(s): 12

Class: Crit, shooting session, lab work

WEEK 11

Topic: Places

Goal: Practice photographing places

Objective(s): Shoot 1 roll of location subjects

Chapter(s): 13

Class: Crit, shooting session, lab work

WEEK 12

Topic: People

Goal: Practice photographing people

Objective(s): Shoot/process 1 roll of portraits

Chapter(s): 14

Class: Crit, shooting session, lab work

WEEK 13

Topic: Putting It All Together

Goal: Practice photographing events

Objective(s): Shoot/process 1 roll of events

Chapter(s): 15

Class: Crit, shooting session, lab work

WEEK 14

Topic: Breaking the Rules

Goal: Explore non-standard subjects and composition

Objective(s): Shoot/process 1 roll of experimental subjects

Chapter(s): 16

Class: crit, shooting session, lab work

WEEK 15

Topic: Color

Goal: Explore color photography

Objective(s): Experiment with "color themes"

Chapter(s): Appendix 2

Class: crit, shooting session, lab work

WEEK 16

Topic: Presentation

Goal: Develop matting and/or exhibition skills

Objective(s): Mat sample prints for portfolio
Produce an exhibit

Chapter(s): Appendix 3

Class: Lab work
(Exhibit/portfolio preparation)

WEEK 17

Topic: Final Project Presentation
The final project might be a report on independent research, a finished portfolio by each student, a class exhibit or other group project, etc.

Goal: Consolidate progress

Objective(s): Submit final project

Class: Final project presentations
(Exhibit/portfolio preparation)

Topic: Final Project Presentation

WEEK 18

& Portfolio Review

Goal: Evaluate progress

Objective(s): Assess each student's progress

Class: Final project presentations, portfolio review

36-WEEK CURRICULUM

Note: Items in parentheses are options that may be added to (or substituted for) basic objectives and schedule or covered incrementally throughout the course (i.e., chapter 1 might be assigned for reading over a week or two possibly followed by independent research by each student on a selected topic).

WEEK 1

Topic: Introduction

Goal: Orientation

Objective(s): Outline schedule and procedures
Review basic camera functions
Survey history and applications of photography

Chapter(s): (1), 2

Class: Camera Demonstration

WEEK 2

Topic: Composition

Goal: Establish fundamentals of good composition

Objective(s): Introduce standards and vocabulary of composition
Practice crit procedures

Chapter(s): 3, 4

Class: Mat & Cropping Exercises, Sample Crit

Topic: Shooting & Processing

WEEK 3

Goal: Begin taking and processing photos

Objective(s): Apply "point of departure" settings

Expose and process a roll of film

Chapter(s): 5, Appendix 1: Processing Film & Prints (B&W)

Class: Demonstration of processing (Field trip to shoot 1st roll)

WEEK 4

Topic: Line

Goal: Explore use of line in photography

Objective(s): Shoot/process 1 roll of "line" subjects

Chapter(s): 6

Class: Crit, shooting session, lab work

WEEK 5

Topic: Texture

Goal: Explore use of texture

Objective(s): Shoot/process 1 roll of "texture" subjects

Chapter(s): 7

Class: Crit, shooting session, lab work

WEEK 6

Topic: Shape

Goal: Explore use of shape

Objective(s): Shoot/process 1 roll of "shape" subjects

Chapter(s): 8

Class: Crit, shooting session, lab work

WEEK 7

Topic: Light

Goal: Explore use of light

Objective(s): Shoot/process 1 roll of "light" subjects

Chapter(s): 9

Class: Crit, shooting session, lab work

WEEK 8

Topic: Motion

Goal: Explore use of motion

Objective(s): Shoot/process 1 roll of "motion" subjects

Chapter(s): 10

Class: Crit, shooting session, lab work

WEEK 9

Topic: Perspective

Goal: Explore use of perspective

Objective(s): Shoot/process 1 roll of "perspective" subjects

Chapter(s): 11

Class: Crit, shooting session, lab work

WEEK 10

Topic: Things

Goal: Practice photographing objects

Objective(s): Shoot 1 roll of still life subjects

Chapter(s): 12

Class: Crit, shooting session, lab work

WEEK 11

Topic: Things

Goal: Practice photographing objects

Objective(s): Shoot 1 roll of still life subjects

Chapter(s): 12

Class: Crit, shooting session, lab work

WEEK 12

Topic: Things

Goal: Practice photographing objects

Objective(s): Shoot 1 roll of still life subjects

Chapter(s): 12

Class: Crit, shooting session, lab work

WEEK 13

Topic: Places

Goal: Practice photographing places

Objective(s): Shoot 1 roll of location subjects

Chapter(s): 13

Class: Crit, shooting session, lab work

WEEK 14

Topic: Places

Goal: Practice photographing places

Objective(s): Shoot 1 roll of location subjects

Chapter(s): 13

Class: Crit, shooting session, lab work

WEEK 15

Topic: Places

Goal: Practice photographing places

Objective(s): Shoot 1 roll of location subjects

Chapter(s): 13

Class: Crit, shooting session, lab work

WEEK 16

Topic: People

Goal: Practice photographing people

Objective(s): Shoot 1 roll of location portraits

Chapter(s): 14

Class: Crit, shooting session, lab work

WEEK 17

Topic: People

Goal: Practice photographing people

Objective(s): Shoot 1 roll of location portraits

Chapter(s): 14

Class: Crit, shooting session, lab work

WEEK 18

Topic: People

Goal: Practice photographing people

Objective(s): Shoot 1 roll of location portraits

Chapter(s): 14

Class: Crit, shooting session, lab work

WEEK 19

Topic: People

Goal: Practice photographing people

Objective(s): Shoot 1 roll of location portraits

Chapter(s): 14

Class: Crit, shooting session, lab work

WEEK 20

Topic: Putting It All Together

Goal: Practice photographing events

Objective(s): Shoot/process 1 roll of events

Chapter(s): 15

Class: Crit, shooting session, lab work

WEEK 21

Topic: Putting It All Together

Goal: Practice photographing events

Objective(s): Shoot/process 1 roll of events

Chapter(s): 15

Class: Crit, shooting session, lab work

WEEK 22

Topic: Putting It All Together

Goal: Practice photographing events

Objective(s): Shoot/process 1 roll of events

Chapter(s): 15

Class: Crit, shooting session, lab work

WEEK 23

Topic: Breaking the Rules

Goal: Explore non-standard subjects and composition

Objective(s): Shoot/process 1 roll of experimental subjects

Chapter(s): 16

Class: Crit, shooting session, lab work

WEEK 24

Topic: Breaking the Rules

Goal: Explore non-standard subjects and composition

Objective(s): Shoot/process 1 roll of experimental subjects

Chapter(s): 16

Class: Crit, shooting session, lab work

WEEK 25

Topic: Breaking the Rules

Goal: Explore non-standard subjects and composition

Objective(s): Shoot/process 1 roll of experimental subjects

Chapter(s): 16

Class: Crit, shooting session, lab work

WEEK 26

Topic: Color

Goal: Explore color photography

Objective(s): Experiment with "color themes"

Chapter(s): Appendix 2

Class: Crit, shooting session, lab work

WEEK 27

Topic: Color

Goal: Explore color photography

Objective(s): Experiment with color density

Class: Crit, shooting session, lab work

WEEK 28

Topic: Color

Goal: Explore color photography

Objective(s): Select any exercise and apply to color

Class: Crit, shooting session, lab work

WEEK 29

Topic: Color

Goal: Explore color photography

Objective(s): Select any exercise and apply to color

Experiment with different films — high speed; various brands; prints & transparencies

Class: Crit, shooting session, lab work

In the remaining weeks, one possibility is to generate an independent or class project. This might be collective work on the yearbook, an exhibit, a publication; independent or group research on various topics; or each student developing an individual portfolio (either employing exercises in the textbook or committing to a specific topic/technique). Alternatively, the four weeks set aside for "projects" could cover special effects printing (Appendix 3: "Manipulation"), flash photography, etc. Goals and objectives will vary according to how projects are defined, but the underlying purpose of this portion of the curriculum is to encourage students to refine their own special interests and aptitudes, either independently or as a group, and to consolidate the progress they have made in the course.

WEEK 30

Topic: Independent/Class Project

Class: Lab work, projects

WEEK 31

Topic: Independent/Class Project

Class: Lab work, projects

WEEK 32

Topic: Independent/Class Project

Class: Lab work, projects

WEEK 33

Topic: Independent/Class Project

Class: Lab work, projects

WEEK 34

Topic: Completion/Presentation of Projects

Class: Mounting an exhibit
Reporting on research
Reviewing portfolios

WEEK 35

Topic: Review & Revision

Class: Reporting on Research
Exercises on weak points
Addition to portfolios

WEEK 36

Topic: Review & Revision

Class: Reporting on Research
Exercises on weak points
Addition to portfolios

ADDITIONAL SOURCES

Films

Write to the following sources for catalogs of films on area artists. For a complete listing of available films, see *Films on Art*, compiled by the American Federation of Arts, published by Watson-Guptill Publications, New York, 1977. Look for revised and updated editions.

Not all of the companies listed here produce materials specifically on photography. In some cases, films, filmstrips, etc. would be used for enrichment/motivation ideas. Check with the suppliers as to specific listings or to obtain catalogs.

American Institute of Architects
1735 New York Ave, NW
Washington, DC 20006

Association Films, Inc.
866 Third Ave.
New York, NY 10022

BBC-TV Enterprises
Manulife Center
55 Bloor St. W., Suite 510
Toronto, Ontario M4W1A5

BFA Educational Media
2211 Michigan Ave.
Santa Monica, CA 90404

Carousel Films, Inc.
1501 Broadway, Suite 1503
New York, NY 10036

Castelli-Sonnabend Tapes
and Films
420 W. Broadway
New York, NY 10012

Canadian Film Institute
303 Richmond Rd.
Ottawa, Ontario K1Z6X3

Embassy of Japan
2520 Massachusetts Ave, NW
Washington, DC 20008

FACSEA
972 Fifth Ave.
New York, NY 10021

Film Images
1034 Lake St.
Oak Park, IL 60301

Films Incorporated
1144 Wilmette Ave.
Wilmette, IL 60091

Indiana University
Audiovisual Center
Bloomington, IN 47401

International Film Bureau
332 S. Michigan Ave.
Chicago, IL 60640

Learning Corp of America
1350 Ave. of the Americas
New York, NY 10019

Leland Auslander Films
6036 Comey Ave.
Los Angeles, CA 90034

Macmillan Films, Inc.
34 MacQueston Pkwy S.
Mount Vernon, NY 10550

Modern Talking Picture Service
2323 Hyde Park Rd.
New Hyde Park, NY 11040

Museum at Large
157 West 54th St.
New York, NY 10019

Museum of Modern Art
11 West 53rd St.
New York, NY 10019

National Gallery of Art
Extension Service
Washington, DC 20565

New York University
 Film Library
26 Washington Pl.
New York, NY 10003

Ohio State University
Dept. of Photography
 and Cinema
156 West 19th Ave.
Columbus, OH 43210

Phoenix/BFA Films and Video
468 Park Ave. S.
New York, NY 10016

Pyramid Films
P.O. Box 1048
Santa Monica, CA 90406

RJM Productions
7012 LaPresa Dr.
Hollywood, CA 90028

Time-Life Films
100 Eisenhower Dr.
Paramus, NJ 07652

University of California
Extension Media Center
Berkeley, CA 94720

Slides, Filmstrips, Videotapes

Many of the companies listed below produce films. Their catalogs will be of help to you in many areas.

Centre Productions
1800 30th St., Suite 207
Boulder, CO 80301

Crystal Productions
Box 12317
Aspen, CO 81612

Educational Audiovisual Inc.
17 Marle Ave.
Pleasantville, NY 10570

Educational Dimensions Group
P.O. Box 126
Stamford, CT 06904

Helvey Productions
P.O. Box 1691
Columbia, MO 65205

International Film Bureau
332 S. Michigan Ave.
Chicago, IL 60640

Son-A-Vision
110 Washington Ave.
Pleasantville, NY 10570

Video-Ed Productions
4301 East-West Hwy.
Hyattsville, MD 20782

Warner Educational Productions
Box 8791
Fountain Valley, CA 97208

Books

Davis, Phil. *Photography*. Dubuque, IA: William C. Brown Co., 1986. A college-level text with detailed technical information on photographic theory and practice. Highly recommended for anyone interested in this aspect of photography.

Eastman Kodak. *Complete Kodak Book of Photography*. Rochester, N.Y. Distributed by Crown Publishers, New York. 1982.

_____ *Joy of Photography*, The. Rochester, N.Y. Distributed by Addison-Wesley Publishing Co., Reading, MA 1983. Both these books are "idea" sources. Excellent photographs, limited information. May inspire students to "try" new things.

Hedgecoe, John. *Pocket Guide to Practical Photography*. New York, Simon & Schuster, 1979. A "must" for all photographic libraries. Contains brief and precise answers to "How do I. . . ?" questions.

Vestal, David. *The Craft of Photography*. New York: Harper & Row. 1978. Recommended for those who wish to achieve a high level of technical skill. Emphasizes black-and-white photography and processing.

There are numerous titles on specialized photographic subjects. For those wishing to pursue this topic, one should consult a library with an extensive photography section. Several titles one might explore are:

The Negative and the Print by Ansel Adams (Amphoto).
The New Zone System Manual by Minor White et al. (Morgan & Morgan)
Close-ups in Nature by John Shaw (Amphoto).
The Photographic Lab Handbook by John Carrol (Amphoto).

EVALUATION AND STUDY AIDS

A simple "fill-in-the-blanks" quiz can be a useful study aid, challenging students to read assigned textbook passages with care and precison. *(Photograph by Dorie Parsons.)*

The following pages contain a selection of sample evaluation forms that you may apply as models or templates, altering them as you wish to suit your own needs and preferences.

The **Critique Form** is designed to serve as a written alternative or addition to verbal crit sessions. Before proceeding to the verbal crit, students might be instructed to fill out a form like this one for each photograph under review. In addition to providing substantial documentation of responses to a given photograph (which may be easier to absorb and assimilate than a barrage of spoken opinions), this procedure will also help train students to organize their perceptions and articulate them clearly and carefully.

The **Photograph Evaluation Form** is intended for use by the teacher, providing a clear and consistent framework for noting key aspects of photographic quality and assignment fulfillment. Once again, students are far more likely to "process" information and criticisms which are presented in this kind of formalized structure, as opposed to casual conversation or handwritten notes. Over time, students will also be able to track their progress by looking back at the evaluations they have received.

The **Reading Worksheet** for chapter 1 is an example of a type of study aid which may significantly enhance students' comprehension of textbook reading assignments. Students fill in the missing words as they read — either on the first "run-through" or as a review exercise (which may be done in the classroom). By turning the reading exercise into a kind of game (find the missing word), a worksheet like this provides motivation and momentum which may otherwise be lacking, especially for students who have not developed good reading skills.

The procedure for producing "fill-in-the-blank" quizzes of this kind is relatively straightforward: Simply select sentences at regular intervals from the text and type them out, replacing one key word in each sentence with a blank space (large enough to be filled in by hand!). In the provided sample, the missing word is generally (though not always) the "key" word of the sentence. Emphasizing new vocabulary terms specific to photography (such as "Daguerreotype") will make the quiz more challenging and help students become familiar with these terms by prompting them to notice the correct spelling and definition.

The **Quiz for Chapter 2** is an example of a more "conceptual" exercise, which requires students to demonstrate comprehension of core ideas in the text. Again, students may be encouraged to refer to the text for answers (or the quiz may be used as a test of acquired knowledge, without reference to the text). The provided answers are (in most cases) intended as general guide-

lines. A reasonable amount of leeway is necessary in a quiz of this kind, as the exact wording of most answers is likely to vary considerably.

Additional quizzes like this one may be derived from the text by noting bold-faced terms or selecting key concepts and devising questions pertaining to them. Note that some questions (such as 13: "Define 'depth of field'") are not easily answered in a few words. Though these have the benefit of being especially challenging — provoking substantial thought — it is important to ensure that the majority of the answers to a quiz of this kind be reasonably simple (lists, single-word answers, etc.), so students do not feel overwhelmed. If students will be permitted to refer to the text, you may wish to provide page number citations (included in parentheses in this sample) to assist with this.

The **Quiz on Film Developing** suggests a useful format for focusing attention on specific procedures. The answers to any of the sample questions may vary, depending the film, chemicals, etc., used in your class. You may also wish to alter the questions (and add others) depending on your own preferences and procedures. (For example, if you include a hypo clearing agent in film processing, then one or more questions pertaining to that should be added.)

Toward the end of the course, you may wish to provide the class with a **Final Examination Study Sheet**, indicating topics with which they should be familiar. The sample provided summarizes key points raised in the text (with parenthetical page references to assist in locating each topic). Once again, you are encouraged to add, subtract and revise to suit your own preferences and needs.

We wish to thank Dorie Parsons (Kubasaki High School; Okinawa) and Joleen Roe (Bethlehem Central High School; Delmar, New York) for contributing evaluation forms on which these samples are based.

Critique Form

What technical aspects of this photograph (such as lighting, focus, print quality, etc.) do you feel are good or excellent?

What technical aspects do you feel detract from the quality or effectiveness of the photograph?

What artistic qualities (such as composition, impact, mood, etc.) do you see in this photograph?

In what ways do you feel this photograph is artistically flawed?

What might the photographer have done to make this photograph better?

Photograph Evaluation

Name _____ Period _____

Assignment _____

Assignment Requirements

Print Size
- ☐ correct
- ☐ incorrect

Choice of Subject
- ☐ meets assignment
- ☐ does not meet assignment

Printing Technique

Contrast
- ☐ good
- ☐ highlights/whites not light enough
- ☐ highlights/whites too light
- ☐ shadows/blacks not dark enough
- ☐ shadows/blacks too dark

Print Exposure
- ☐ good
- ☐ over-exposed (too dark)
- ☐ under-exposed (too light)
- ☐ needs dodging: _____
- ☐ needs burning: _____

Print Quality
- ☐ good, clean print
- ☐ dust on negative
- ☐ scratches on negative
- ☐ air bubbles in processing
- ☐ water spots on negative
- ☐ dented emulsion
- ☐ negative reversed
- ☐ paper is fogged
- ☐ chemical stains

- ☐ fingerprints
- ☐ tong marks
- ☐ uneven developing
- ☐ incomplete fixing
- ☐ etc: _____

- ☐ Reprint and submit again

Composition

Center of Interest
- ☐ adequate
- ☐ strong
- ☐ missing

Cropping
- ☐ effective
- ☐ reposition to correct tilted horizon line
- ☐ crop tighter: _____
- ☐ cropped too tight: _____
- ☐ change to vertical format
- ☐ change to horizontal format

Depth of Field
- ☐ effective
- ☐ acceptable
- ☐ too shallow:
 _____ should be in focus
- ☐ too deep:
 _____ should not be in focus

Focus
- ☐ sharp
- ☐ almost sharp
- ☐ poorly focused
- ☐ effective use of selective or soft focus
- ☐ camera shake
- ☐ moving subject
- ☐ effective use of blurred motion

Originality

Choice of Subject
- ☐ compelling
- ☐ interesting
- ☐ adequate
- ☐ dull

Point of View
- ☐ common
- ☐ unusual

Comments:

Work on:

Grade A B C D F **Please mount this print** **Extra Credit**

Name _____ Period _____

Please read pages 10-15 in *The Photographic Eye: Learning to See with a Camera*. Fill in this worksheet as you read. You are responsible for the material to be read. Be sure to spend some time looking at the pictures.

1. Photography began as a curiosity and has grown into a _____ influence on our society.

2. We encounter hundreds of photographs every day, some with tremendous impact, some with _____ .

3. How long has photography been around? Any guess over _____ years would be reasonably correct.

4. There isn't any one _____ answer.

5. No one person can be credited with _____ photography.

6. The first printed photographs were made between 1816 and _____ .

7. The first recorded discovery that a certain chemical turned black when exposed to light was made in _____.

8. The basic design of the camera has been in use since the _____.

9. The _____ figured it out even longer ago than that—as early as the fourth century.

10. Photography is between _____ and 150 years old.

11. The first stage of photography's _____ in Europe was the camera obscura.

12. Camera is Latin for chamber; obscura means _____.

13. The camera obscura was a room with one tiny hole fitted with a _____.

14. The image was upside down and not very _____ but it could be traced.

15. Portable versions of the camera obscura were developed by the _____ .

16. In 1725 Johann Heinrich Schulze discovered a mixture that turned _____ in sunlight.

17. Silver salt was causing the reaction to _____.

18. Schulze never thought that his discovery might have any _____ application.

19. In 1777 Carl Wilhelm Scheele discovered that ammonia would dissolve the silver chloride and leave the image _____.

20. The basic chemistry of photography (exposing silver chloride to produce an image and _____ it with ammonia) was established.

21. In France, Joseph Niepce developed an emulsion or _____-sensitive varnish.

22. Instead of turning black, this material is _____ by light.

23. To produce an image, emulsion on glass or pewter was exposed to light and then _____ with solvents.

24. The solvents dissolved the unexposed emulsion, producing the world's first _____ camera image.

25. It was only some blurs of light and dark and the exposure took _____ hours.

26. In Paris, Louis Jacques Mande Daguerre discovered that if a silver plate were iodized, exposed first to light and then to mercury vapor, and finally fixed with a salt solution, then a _____, permanent image would result.

27. This was the first photographic process to be used outside of a laboratory: the _____.

28. In England, William Henry Fox Talbot succeeded in producing photographs. The first exposure produced a negative image on _____.

29. The exposed paper was placed over a second sheet of treated paper and exposed to a bright light, producing a _____ image.

30. Talbot's process—called a calotype—enabled photographers to make _____ copies of a single image.

31. Because the calotype's image was transferred through a paper negative it was not as _____ as the daguerreotype.

32. In 1851, Frederick Scott Archer introduced the collodian wet-plate process which produced a high
_____ image and multiple copies.

33. The collodian process was _____ to use.

34. A clean glass plate had to be coated with collodian and while still damp, the plate had to be dipped into silver nitrate,
inserted into the camera and exposed, then developed _____.

35. Photography, dominated by the collodian and daguerreotype processes, began to _____ off.

36. Cameras were used to photograph portraits, landscapes and _____.

37. _____ collected inexpensive prints of local attractions.

38. The stereoscopic camera that produced a _____ image was introduced in 1849.

39. As early as 1850 _____ of photographs were published showing the harsh conditions
of life in England and the U.S.

40. Lewis Hine produced powerful photographs that helped to bring about new _____ to protect
children's rights.

41. At the start of the Civil War, Mathew _____ asked for permission to carry his cameras
onto the battlefields.

42. In the 1880s, Eadweard Muybridge invented the zoopraxiscope that produced a series of images of a
_____ subject.

43. Though early photographers often achieved a high degree of aesthetic quality, their primary purposes were
_____.

44. They were to promote social reform, record events and aid _____ investigations.

Name _____ Period _____

Please read pages 10-15 in *The Photographic Eye: Learning to See with a Camera.* Fill in this worksheet as you read. You are responsible for the material to be read. Be sure to spend some time looking at the pictures.

1. Photography began as a curiosity and has grown into a ____major____ influence on our society.

2. We encounter hundreds of photographs every day, some with tremendous impact, some with ____none____ .

3. How long has photography been around? Any guess over____150____years would be reasonably correct.

4. There isn't any one ____correct____ answer.

5. No one person can be credited with ____inventing____ photography.

6. The first printed photographs were made between 1816 and ____1840____ .

7. The first recorded discovery that a certain chemical turned black when exposed to light was made in __1725__ .

8. The basic design of the camera has been in use since the ____1500s____ .

9. The ____Chinese____ figured it out even longer ago than that—as early as the fourth century.

10. Photography is between ____1,500____ and 150 years old.

11. The first stage of photography's ____evolution____ in Europe was the camera obscura.

12. Camera is Latin for chamber; obscura mean ____dark____ .

13. The camera obscura was a room with one tiny hole fitted with a ____lens____ .

14. The image was upside down and not very ____clear____ but it could be traced.

15. Portable versions of the camera obscura were developed by the ____1660s____ .

16. In 1725 Johann Heinrich Schulze discovered a mixture that turned ____purple____ in sunlight.

17. Silver salt was causing the reaction to ____light____ .

Early Photography — Reading Worksheet for Chapter 1 — Answers

Name _____ Period _____

18. Schulze never thought that his discovery might have any __practical__ application.

19. In 1777 Carl Wilhelm Scheele discovered that ammonia would dissolve the silver chloride and leave the image __intact__ .

20. The basic chemistry of photography (exposing silver chloride to produce an image and __fixing__ it with ammonia) was established.

21. In France, Joseph Niepce developed an emulsion or __light__ -sensitive varnish.

22. Instead of turning black, this material is __hardened__ by light.

23. To produce an image, emulsion on glass or pewter was exposed to light and then __washed__ with solvents.

24. The solvents dissolved the unexposed emulsion, producing the world's first __permanent__ camera image.

25. It was only some blurs of light and dark and the exposure took __8__ hours.

26. In Paris, Louis Jacques Mande Daguerre discovered that if a silver plate were iodized, exposed first to light and then to mercury vapor, and finally fixed with a salt solution, then a __visible__, permanent image would result.

27. This was the first photographic process to be used outside of a laboratory: the __daguerreotype__.

28. In England, William Henry Fox Talbot succeeded in producing photographs. The first exposure produced a negative image on __paper__.

29. The exposed paper was placed over a second sheet of treated paper and exposed to a bright light, producing a __positive__ image.

30. Talbot's process—called a calotype—enabled photographers to make __multiple__ copies of a single image.

31. Because the calotype's image was transferred through a paper negative it was not as __clear__ as the daguerreotype.

32. In 1851, Frederick Scott Archer introduced the collodian wet-plate process which produced a high-
 __quality__ image and multiple copies.

33. The collodian process was __difficult__ to use.

34. A clean glass plate had to be coated with collodian and while still damp, the plate had to be dipped into silver nitrate,
 inserted into the camera and exposed, then developed __immediately__.

35. Photography, dominated by the collodian and daguerreotype processes, began to __take__ off.

36. Cameras were used to photograph portraits, landscapes and __battles__ .

37. __Tourists__ collected inexpensive prints of local attractions.

38. The stereoscopic camera that produced a __three-dimensional__ image was introduced in 1849.

39. As early as 1850 __books__ of photographs were published showing the harsh conditions
 of life in England and the U.S.

40. Lewis Hine produced powerful photographs that helped to bring about new __laws__ to protect
 children's rights.

41. At the start of the Civil War, Mathew __Brady__ asked for permission to carry his cameras
 onto the battlefields.

42. In the 1880s, Eadweard Muybridge invented the zoopraxiscope that produced a series of images of a
 __moving__ subject.

43. Though early photographers often achieved a high degree of aesthetic quality, their primary purposes were
 __practical__ .

44. They were to promote social reform, record events and aid __scientific__ investigations.

Quiz for Chapter 2 — Tools

1. List two important choices you should consider before buying a new camera.

2. What is an interchangeable lens?

3. What is a fixed lens?

4. What is a "fixed focal-length" lens?

5. What is a "zoom" lens?

6. What does "manual override" allow you to do?

7. What does "grain" mean in photography?

8. What is the most important benefit of using a "UV" or "skylight" filter?

9. What is a contact sheet?

10. Describe a situation in which you might choose ISO 400 film instead of ISO 64 film?

11. What does "aperture" mean?

12. Which aperture is larger: f4.5 or f8?

13. Define "depth of field."

14. What aperture might you choose for shallow (or narrow) depth of field and what effect might you achieve with it?

15. List three conditions in which a fast shutter speed is useful.

16. Which lens most closely matches human vision:

____200mm ____75mm ____50mm ____28mm

17. What happens if you change lenses while there is film in your camera?

Quiz for Chapter 2 — Tools — Answers

1. List two important choices you should consider before buying a new camera. *(page 36)*

 A. fixed or interchangeable lens(es)
 B. manual or automatic exposure

2. What is an interchangeable lens? *(page 36)*

 One that can be removed from the camera body

3. What is a fixed lens? *(page 36)*

 One that cannot be removed

4. What is a "fixed focal-length" lens? *(page 39)*

 One in which the angle of view or "length" (the distance between the optical center and the film plane) cannot be adjusted.

5. What is a "zoom" lens? *(page 39)*

 One in which the length can be adjusted

6. What does "manual override" allow you to do? *(page 37)*

 Select a different exposure than recommended by the light meter

7. What does "grain" mean in photography? *(page 37)*

 The size of the "dots" which create a photographic image

8. What is the most important benefit of using a "UV" or "skylight" filter? *(page 39)*

 It protects the lens from being scratched

Quiz for Chapter 2 — Tools — Answers

9. What is a contact sheet? *(page 40)*

 A same-size print of all the frames on a single roll of film, used for evaluating the images and deciding which to enlarge

10. Describe a situation in which you might choose ISO 400 film instead of ISO 64 film?

 Any situation in which the light is low, the subject or photographer is in motion, or a "soft" or grainy effect is desired

11. What does "aperture" mean? *(page 47)*

 The size of the lens opening

12. Which aperture is larger: f4.5 or f8? *(page 47)*

 f4.5

13. Define "depth of field." *(page 47)*

 The range of distances from the camera which will be in sharp focus at any one time

14. What aperture might you choose for shallow (or narrow) depth of field and what effect might you achieve with it? *(page 47)*

 Example: f4.5 — To achieve the effect of a subject in focus with a blurred background.

15. List three conditions in which a fast shutter speed is useful. *(page 36)*
 A. subject is in motion
 B. shooting in low light
 C. using a long lens

16. Which lens most closely matches human vision: *(page 39)*
 ___200mm ___75mm ___50mm ___28mm

 50mm

17. What happens if you change lenses while there is film in your camera? *(page 39)*

 You must figure out this one on your own — it depends on your camera.

Film Developing — Photography

Choose the most correct answer.

1. The type of developer we use is
 A. Dektol
 B. Microdol-X
 C. Microdol-X (1:3)
 D. Photo-flo

2. The best temperature for the developer is
 A. 55°
 B. 68°
 C. 75°
 D. 100°

3. At this temperature, film should remain in the developer for
 A. 1 minute.
 B. 5 minutes.
 C. 15 minutes
 D. 30 minutes.

4. After pouring developer into the processing tank, you should
 A. agitate the tank continuously for the entire developing time.
 B. set the tank on a flat surface without shaking it and leave it there for the entire developing time.
 C. agitate the tank for 5 seconds at 30-second intervals.
 D. agitate the tank occasionally for what feels like the "right" amount of time.

5. At the end of the developing time, you should
 A. open the developing tank and check to be sure the film has been developed correctly.
 B. pour the developer back into its container.
 C. leave the developer in the tank and pour in a small amount of stop bath.
 D. pour the developer down the drain.

6. Film should remain in the stop bath for
 A. 5 minutes.
 B. 30 seconds.
 C. 1 minute.
 D. between 1 and 5 minutes, depending on the type of film.

7. After completing the stop bath, film should be
 A. washed for 30 minutes, then fixed.
 B. fixed for 30 minutes, then washed.
 C. fixed for 5 minutes, then washed.
 D. washed for 5 minutes (fixing is optional, but not necessary).

8. To focus the negative in an enlarger, you should
 A. use the largest aperture.
 B. use the smallest aperature.
 C. use whatever aperture looks best.

9. The correct exposure for printing a negative is
 A. 5 seconds at f8.
 B. 10 seconds at f4.5.
 C. determined by making a test strip.
 D. determined by trail and error.

10. To develop the print normally, you should
 A. allow the paper to sit in the tray with no agitation for the entire developing time.
 B. agitate the paper occasionally while it is developing.
 C. turn the paper over at 30-second intervals while continually agitating the tray.
 D. agitate continually and remove the print as soon as it looks right.
 E. agitate continually and remove the print when it looks slightly underexposed.

11. The best way to increase the contrast of a print is to
 A. use a large aperture and then remove the print from the developer as soon as it looks right.
 B. use a small aperture and develop the print for at least 15 minutes.
 C. use higher-contrast paper.
 D. agitate the paper continually while it is developing.
 E. rub the paper with your hands while it is developing.

12. After the print has been properly developed, you should:
 A. place it in the stop bath for 15-30 seconds.
 B. place it in the stop bath for 5 minutes.
 C. rinse it off in the stop bath and place it in the fixer.
 D. rinse it with running water.

13. The print should remain in the fixer for
 A. 1 minute with continual agitation.
 B. 5 minutes with agitation for 5 seconds at 1-minute intervals.
 C. 10 minutes with agitation for 5 seconds at 30-second intervals.
 D. 10 minutes with no agitation.

14. After fixing, the print should be
 A. washed for 1 minute
 B. washed for 10 minutes
 C. washed for 20 minutes
 D. returned to the stop bath for 1 minute, then washed for 5 minutes.

Answers:

1, 2, 3, 13, 14: Answers to these questions will depend on your own procedures.

4: C, 5: D, 6: B, 7: C, 8: B, 9: C, 10: C, 11: C, 12: A

As part of your preparation for the photography final exam, you may want to review the topics included in this list. You should be familiar with all of them — understanding not merely what the words mean, but how they apply to photography in practice. The numbers (in parentheses) indicate pages of *The Photographic Eye* where you will find information on each topic.

Cameras	Composition & Technique	Darkroom
camera obscura (11)	line (56-59)	working solution (229)
daguerreotype (12)	shape (60)	grain focuser (236)
interchangeable lens (36, 280)	balance (60-61)	contrast grades (232)
manual override (37)	dynamics (61-63)	surface texture (232)
ASA/ISO (42, 279)	weighting (55, 280)	emulsion (12, 227)
shutter speed (42-43, 48, 280)	cropping (65, 74)	test strip (235)
aperture (47, 48, 279)	value (68-70)	dodging and burning (238-239)
single-lens reflex (48)	negative space (60, 280)	fogging (233, 241)
fast and slow lenses (139)	bracketting (123, 127)	
focal length (39, 138, 279)	panning (132)	
depth-of-field (124-126)	flash fill (268)	
angle-of-view (129-131, 138)	zone focusing (182)	

The Photographic Eye
Correlations to Essential
Elements and TAAS

Contents	Page	Essential Elements	TAAS
Chapter 1: From Blurs to Big Business	11-31	1A, 2B	R1, R2, R3, R6
	21-23, 29	1B	
	9-31	3A, 3B	
	9-27, 29, 30	4A, 4B	
	31	2A	
	11-14, 16, 21-23, 26, 27, 31		R4, R5
	Focal Point: 18-21, 24, 28, 29	3A, 3B	
Chapter 2: Elements of Composition	35-49	1A, 2B	R1, R3, R5, R6
	33, 36, 38, 39	1B	
	37, 38	1C	
	40, 48, 49	2A	
	34-38	3A, 4A, 4B	
	41-47		R2, R4, R5
	Exercise: 48, 49	2A	R2, R4, R5
Chapter 3: What is Composition?	50-65	1A, 2B	R1, R3
	50-63	1B, 1C	
	54-63	2A	R2, R4, R5
	50-60, 62-65	4A, 4B	
	Exercise: 64, 65	2A	R2, R4, R5
Chapter 4: Developing a Critical Eye	67-81	1A, 2B, 4A, 4B	R1, R2, R3, R4, R5, R6
	68-70, 74	1B	
	66, 68-81	3A, 3B	
	Exercise: 76-81	1B, 1C, 4A, 4B	R2, R3, R5, W5, W6, W7
Chapter 5: Point of Departure (f/16 @ 1/25)	82-85	1A, 2A	R3, R4, R5, R6
	84, 85	1B, 1C	
	82, 84, 85	3B, 4A, 4B	
	82-84		R1, R2

Contents	Page	Essential Elements	TAAS
Chapter 12:	150-165	1A, 2B	R1, R3
Things	150, 152-165	1B, 1C	
	150, 151, 154-165	3B, 4A, 4B	
	Focal Point: 152, 153	3A, 3B, 4A, 4B	
	Exercise: 154-165	2A	R2, R4, R5, R6
Chapter 13:	166-179	1A, 2B	R1, R3, R6
Places	*Focal Point:* 168, 169	1B, 1C, 3A, 3B,	R1, R3
		4A, 4B	R1
	Exercise: 170-179	1B, 1C, 3B, 4A,4B	R2, R4, R5
Chapter 14:	180-195	1A, 2B, 3B, 4A, 4B	R3, R6
People	181-183		R1, R2, R4, R5
	Focal Point: 184, 185	1B, 1C, 3A	
	Exercise: 186-195	2A, 4A, 4B	R2, R1, R4, R5
	Exercise: 186, 190, 191, 194	1B, 1C	
Chapter 15:	197, 198, 200, 202-204, 206	1A, 1B, 1C, 2B	R1, R3, R4, R5, R6
Putting it all	*Focal Point:* 198, 199	1A, 3A	
Together	*Exercise:* 202-207	2A, 3B, 4A, 4B	R2
Chapter 16:	208-225	1A, 2B, 4B	R1, R3
Breaking the Rules	209	4B	
	210	1B, 1C	
	Focal Point: 210-211	1B, 1C, 3A, 3B	R1, R3
	Exercise: 218, 222, 224, 225		W5, W6, W7
	Exercise: 218-225	1B, 1C, 2A, 4B	R2, R4, R5, R6